Learn Ho
Caric
For the Abso

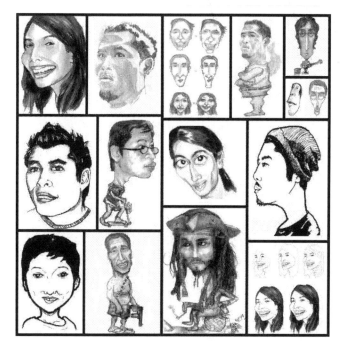

Adrian Sanqui and John Davidson

Learn to Draw
Book Series

JD- Biz Publishing

All Rights Reserved.
No part of this publication may be reproduced in any form or by any means, including scanning, photocopying, or otherwise without prior written permission from JD-Biz Corp and at http://JD-Biz.com.
Copyright © 2014
All Images Licensed by Adrian Sanqui
Fotolia and 123RF

Read More "Learn How to Draw" Books

TABLE OF CONTENTS

Introduction	4
Quick Ink Sketches	5
Caricature of a Child	6
Head in profile	11
Establishing tones/ shade values	18
Drawing a Face in a Proper Proportion	20
Drawing Caricatures with a Pencil	26
Adding Cartoon Bodies to your Realistic Portrait	34
Starting with a Facial Feature	36
Exaggerating Proportions	41
Caricature of a girl – Amplifying facial expression	44
Drawing Detailed Caricatures of Children	52
Drawing Caricatures of Children and Animals	54
Make Money Drawing Caricatures	56
Caricature Samples	58
Read our other books	61

Introduction

To draw a caricature is to simply draw an image that is very distinguishable to your model/subject's identity with or without being photographically identical. In early forms of this genre, the type of figures used was animals to represent a certain person. A painting or any type of artwork cannot be called a caricature if the piece does not involve an actual person, because involving a real person as a model is the critical part of this genre.

So start taking pictures of your friends or ask for a willing volunteer to be your model and begin drawing caricatures.

If nobody is willing to be your model, it's okay. I have a few pictures of my friends here and they are more than willing to be models for practicing, mess up their facial features. It's totally fine, they don't care.

Follow the steps in this book and become a caricature artist in a short amount of time.

Learn how to draw caricatures easily without any formal training. This book will guide you how faces take form step by step, how to base on a model and produce a caricature portrait with ease.

This instruction booklet will teach you how to draw caricatures quickly with the use of a simple pen and marker, and then move on to using pencil and start conveying shade values and produce realistic portraits with cartooned bodies.

Good luck and I hope you enjoy reading!

Quick Ink Sketches

Neat ink sketches such as the examples below can go a long way, from simple logos, intricate image layouts and up to several decorative illustrations.

All you need to know is how to use thick and thin lines effectively, and how to show the features and definitions of the needed portions by capturing the darkest tones alone.

These sketches, as I've said before, define the edges and shadows which is already enough to distinguish the image.

However, they lack in choices of texture and definitive dimension value. They only define dimensions by adapting the look of any feature in a manner that the viewer can easily perceive its angle.

In this case, it is a little hard to illustrate images or forms that is atypically seen or not easily perceived, like illustrations of a surreal scene with objects with a same size in different distances might be perceived as objects with different sizes in a same distance (visual perspective confusion).

Caricature of a Child

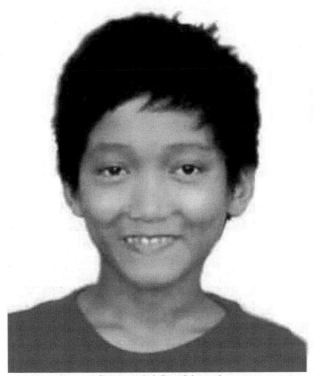

Our model for this task

A good way of honing your observation skills is having a model to sketch. Trying to render a specific appearance is always a challenge. A starter seldom fails at first trials when doodling with ink and consistently committing minor errors such as obvious improper distance between each features or noticeable misalignments.

Aim for making a semi realistic cartoon drawing of this child.

This example is intended to show you how the thick and thin lines relate to each other when sketching with ink. And show you how to figure out the proper placements of his features based on the main shape of his head.

The key is to sketch it in a good step-by-step process.

Step 1
Begin with the most identical part from the shape of the head. In this angle(front view), both sides should be or nearly equal, start from the part near to the ears, ending to the chin, and do the same way on the other side.

Next should be the inner outline of the hair, since this part interacts to the shape of the face it affects the actual size of the head. This should help you figure out where the facial features are placed, especially the ears.

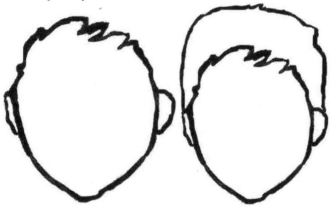

Step 2
Now, begin drawing the ears, the size of our model's ears was affected by his hair so just draw it how you see it. A right placement of the ears is helpful for the next steps; this will help you have a more appropriate basis for placing the other facial features.
(A child's' ears are usually placed nearly at the middle of the head, just right above the space of the jaw line and farther from the definite end of the forehead)

Step 3
Next is the outer side of the hair, this defines the actual size of the head for your cartoon/caricature, the thickness of our young model's hair is just as the same distance to his ears, curvy at one side and a little improperly brushed on the other.

Learn how to Draw Caricatures

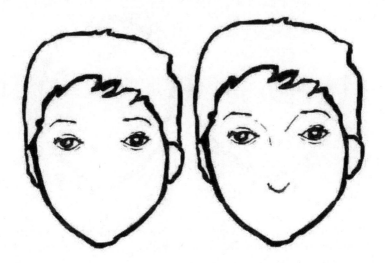

Step 4
Now that we completely defined the size of the head with the ears drawn, base on it for the placement of both eyes. In this case, our model's eyes have a little difference with each other. It is one of his unique features that you will notice with a very brief observation.

His eyebrows are thin, just like his eyelashes that are quite feminine his eyebrows are a little feminine as well. Draw it with a controlled thinness and pointy edge.

- When simplifying the appearance and turning your model into a cartoon, details like the uniqueness of a model's eyes should be one of the features you must strongly consider and notice.

Step 5
Draw a small thin line for his nose line, our model's nose bridge does not stand out so leave that part unmarked. The nose line gives a visual illusion that perfectly substitutes the absence of the nose bridge's visibility for distinguishing a nose. these types of intentional breaks are call implied lines.

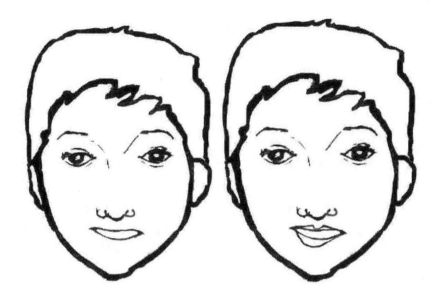

As you can see, he has a thin upper lip, so making a certain portion of the lip lining overlap the mouth opening is just appropriate. This signifies a thin upper lip effectively.

His lower lip is expressive; show that little expression in a wider movement. Small expressive elements of a caricature like this helps for making a decent humor to the person being drawn, especially if it's only a neck to head portrait.

The last portion of the mouth that should be drawn is the teeth details. Not all kind of teeth are illustrated this way, but in this case, since he is a child his teeth features are unique and I think it should show in this caricature sketch. Observe the small gaps and

the gums slightly showing. Try to make it look funny but not humiliating, otherwise his parents may love it but the actual young model might find it insulting.

- Capture the small details with thin diminishing lines, you would not want it to draw too much attention and it might actually mess up the whole image.

In a colored or shaded sketch the proportion values and minor details of an object or a subject/person is made by shifting color tones or shade value, but since this one is a simple line drawing and we are aiming for a neat sketch, we illustrate facial muscle details with thin lines, simple enough to be credibly visible and distinguishable.

- Finish the drawing by filling up the parts with a marker. Shade the hair and apply hatches underneath the chin.

Because our model is a child with a typical or generic proportion (based on his actual neck size), I decided to draw a neck of a typical cartoon child, thin and short. And match it with his loose shirt and a little collar bone showing.

With this kind of sketches, you can finish a portrait like this one in more or less 5 to 7 minutes. For beginners this would probably take 10 to 15 minutes.

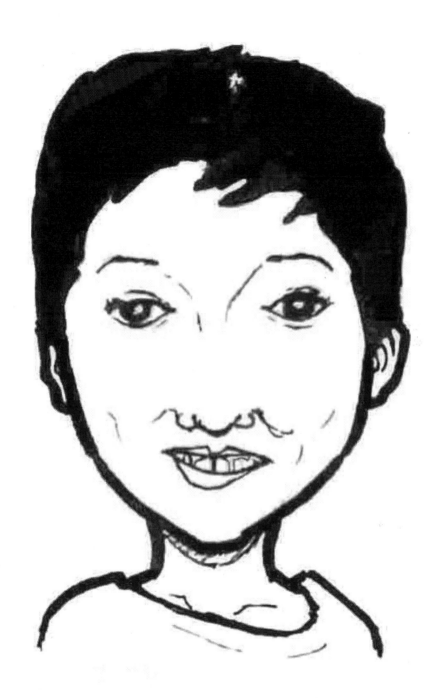

Head in profile

A cartoon of a young man is your next drawing exercise, this time let us try to draw a person in side view.

For most starters, drawing a person in perfect or imperfect side view seems hard, this is because a lot of curved lines that should define facial features in a single side can easily end up disproportioned;

Even if drawing a person in a side view angle looks too rigged since the defining of the features is all about curved lines, alignments can be established.

But once you get used to drawing different form of faces then this task is easier than drawing a face in front view since only the side of every feature of the head is active and there wouldn't be any misalignments, such as misaligned eyes, nose drawn too long or too short which you would most probably encounter when drawing faces in front or quarter-side view.

You should try things first before saying that it's a hard shape to capture; only if you try it and then you'll know that it's actually easier and way faster.

One common slacking excuse of an artist is the fear of not drawing something he's not used to, so try to get rid of this bad habit, especially if you want to be a portrait or a caricature artist because you will be drawing faces in different angles all the time.

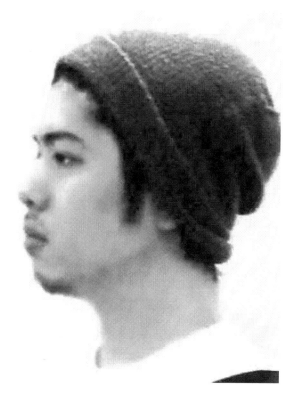

Our model for this task

Our model is wearing a bonnet. Compared to our previous model this one has less face details but more on styling and décor, very visible and masculine facial hairs, and obviously older.

The method will be a little different since you will draw only the sides of each facial feature.

- The flow of the process depends on the shape of the face, and in this case it is easier to start with the forehead or ridge of the eyebrows.

I prefer starting at the part with less undisturbed line with most length which is the forehead.

- It is better to create a curvy line that signifies the part of his forehead and down to his chin in a single stroke.

You could see here that I stopped and changed the thickness of the outline for the forehead down to the eyebrows and just created another line for the chin and up to the edge line of the nose. I find it easier to define the texture of a slender face when I make

separate lines meet, but still, it depends on the kind of texture, angular or the smoothness of the lines needed to define the ridges of a plain (shape of the head in profile), especially if the form is going to be defined by signatory lines (free-form line strokes).

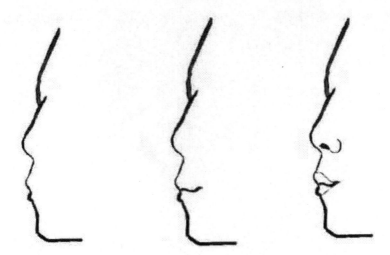

Our model is not smiling, but a frowned-face caricature portrait is less pleasing. So give him a little smile, make a good guess on how it would look like if the person would smile just a little.

You may not know if he has dimples or any kind of muscular detail if his mouth stretches widely, especially if you are just basing on a single picture. So it is easier and a safer way to guess is just to throw in a little smile or smirk to the portrait.

- Establish the single nostril that is shown in this head angle. Nostrils appear differently when in side view compared to a face in front view.

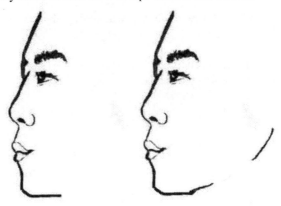

Draw the shown eye and the eyebrows. The shape of the facial features is always different depending on the head angle.

- Just observe our model and you will easily figure out the eye shape, and the same goes for his eyebrows.

The jaw line of our model is hardly seen; make a broken lining or a broken detail (implied lines) in this case to signify a non-angular/feminine jaw. And the distance should define the size of his face from left to right excluding the hair's thickness. This detail will help you for establishing the distance of his ear to the whole shape of his head (from the portion with the most active curved lines and to the jaw), so you should consider this since the ear will be right behind it.

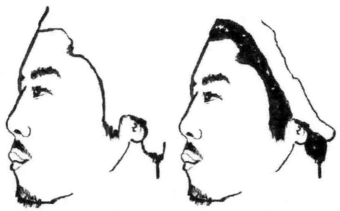

Now you should define the size of the head completely.

- Check if the portions are correct by basing on the space from the ends of the hair and to the other side, the little gap between the eye and the nose bridge outline, and the distance of inner hair outline from the space of the forehead.

- Place the ear on the upper end of the jaw outline, leveled with the lower end of the nose and upper lip.

These observations are not far from a traditional head feature proportioning, but the portions I base upon while figuring out the distances close enough to resemble our model is based on the model alone.

- Without the use of any reference lines, the leveling of his facial features are based independently on his own features as well.

I rendered the facial hairs with strong toned short lines.

- Black-colored hairs can easily dominate strong lines in small proportions by having a larger proportion with a solid black definition.

There are details in his bonnet I considered. The lining patterns on his bonnet shows the dimension of the head effectively aside from its minor crumples.

- Instead of using light and thin lines on a preferable portion of the bonnet, I decided to use cross- contouring.

In this way, the contour lines could serve as a texture while it defines its dimensional shape as well.

I tried to capture the details of his bonnet by considering the ridges that affect the lines, and the manner of how and in what direction it should be bending to and from.

- Add cross-hatches to signify the portion with the strongest tone.

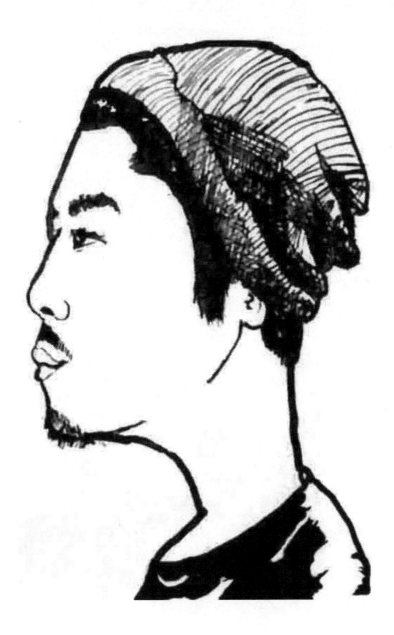

Establishing tones/ shade values

As an object or portion gets farther from the light source, it gradually looses brightness. And as the angle of an object opposes the point of light, it loses brightness even further.

A middle tone is used to define the depth according to light's direction, thus, gives an object a better impression of its proportions.

But Ink lacks a middle tone and cannot be blurred to lighten (unless dabbed with water which is not much for a solution).

Ink illustrations are given a sense of depth and multi-dimension values through line strokes in different volumes and direction. The idea is to manipulate the visibility of the plane (white pad) by blocking its exposure with overlapping lines

There are few ways to initiate this:

Hatching/Contour hatch

A contour is a definition of an object's exact shape, including its texture and dimension properties. The main idea of contouring is to mark a line that establishes any kind of details that a keen eye can observe from his subject.
Contour hatches are lines that follow the object's pattern by bending with its dimensional shape. It controls the brightness by gradually adjusting the gaps between the line marks.

Cross-hatch

Crosshatching is used to define an object's dimension by focusing on the shifting of tones and less on definitive line flow. It is basically initiated by making a set of parallel lines that defines the dark and bright tones by decreasing and increasing the number of hatch lines per set.

Shades are darkened by overlapping the pervious set of lines with another set of lines in any opposing direction, until it reaches the preferred kind of thickness and depth.

Stippling

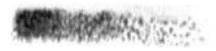

It is a method that portrays an object's dimension by a careful distribution of dot marks. Stippling provides different shade values by adjusting the spaces between each dot.

Stippling is most effective when using a medium that can only produce a single tone (sign pen and markers). Although it takes a lot of time to finish a single image and the pressure applied on the pen should be consistent which is tiring.

Scumbling

Defines depth or gives texture to an image by making squiggly circular line strokes in a repeated and continuous manner. This form of shading is often initiated by making short freeform hand strokes with a shape of the number 8.

Those ways of establishing the dimensions with ink are effective if applied properly. Each of them can bring out different textures, or rather, chosen according to the texture they could bring out.

Other artists even prefer using more than one style of applying shade values in a single illustration when they try to depict texture and depth.

Drawing a Face in a Proper Proportion

For an introduction to sketching realistic faces, I will show you how a face with a proper proportion is drawn. I will base on a model and try to portray his exact look (proportion of facial features and proper distances inside the main head frame)

This exercise is intended to teach you how a face of an actual person is rendered or copied, to turn a picture or a live model into a quick drawing by simple line renditions.

I am going to use a black ball-point, medium line marker and a fine point pen. The marker is for the thick lines and the sign pen is for the minimal hatching and other small details. This sketch should only take more or less ten to fifteen minutes (probably 15 to 20 minutes for a beginner).

Observe the features of our model below;

he has a typical-size head proportion and distinct facial features of a man. Although what you might probably notice in your first gaze is his thick eyebrows and indistinctly sad eyes.

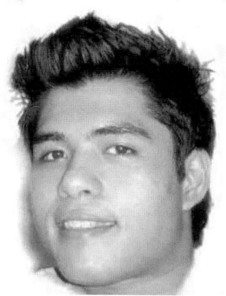

Our model for this task

The Angle of his eyes is not precise but they are still relatively aligned. His left eye is indistinctly lower than the right eye because the head is almost in a quarter view angle. The other ear is completely hidden.

- A head in a quarter- turn position will show a defined nose bridge, usually hides the farther ear, and slightly changes the diagonal alignment of the proportion of other features (mouth and eyes).

The shape of the chin is obvious and the jaw line is visible, let us use these characteristics to define the mass of his head.

- It is easier to start with the distinctive edge lines (like I did before), from the forehead and up around the jaw that ends to the shown ear.

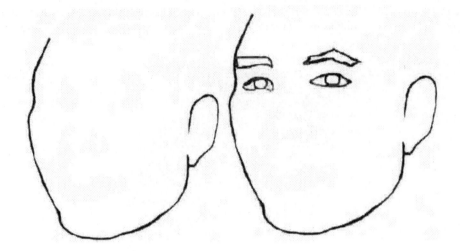

- Once the head's outline is established, draw the eyes and eyebrows next.

Remember that because of his angle, there is a significant change in the shape of his eyes and eyebrows. I decided to draw and shape both of them individually.

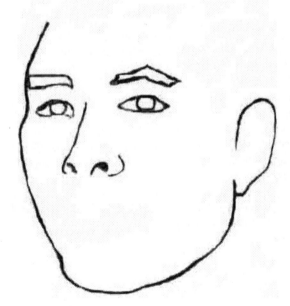

Next is the nose; render the nose bridge and the nostrils. The exact look of his nose will be defined by the edge line of his nose bridge, and the angle will become more defined after placing his nostrils according to how it looks like with a quarter- turned base.

- Start with the mouth opening before drawing the lower and upper lip; in this way it is easier to distinguish the thickness of the lips and its actual distance from the nose and the chin.

- When drawing a typical (not exaggerated or simplified) mouth size, the ends of the mouth are usually aligned at the center of both eyes, but this should also adjust according to the angle of the face position and the mass of the head.

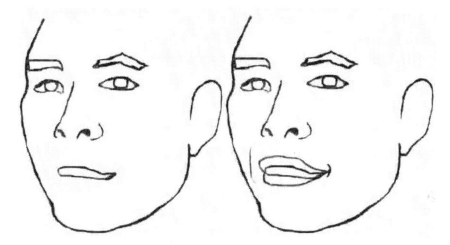

And when the mouth opening is done, complete it by drawing the outline of his lips and the visible dimples created with his smile. Our model is between 20 to 24 years old. Exaggerating or completely outlining his dimples will make him look older, so mark his dimples lightly.

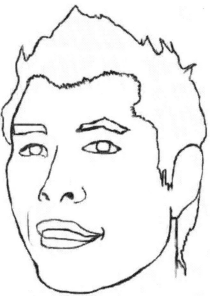

- Complete the shape of the whole head by making line strokes according to the direction of his hairstyle.

Since his hair is black, you could easily finish this part with the marker alone. The bright parts of his hair are established by leaving few spaces unmarked to create highlights. These unmarked (white) highlights should describe which way his hair strands are directed to portray the manner his hair is fixed and stylized.

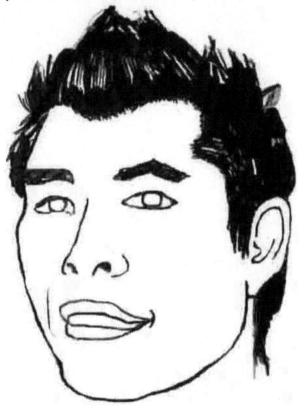

- His eyebrows are thick, you could finish this part by simply filling it up using a black marker while leaving thin and diminishing white highlights.

Now, to fill the drawing and to establish the dimensional characteristic of the head, slightly shade the farther side of his head and the features that should have an obvious depth.

I used a sign pen to initiate linear shades quickly by cross-hatching. Overlapping parallel lines to the opposite direction will darken the portion.

Be careful with your line strokes when cross-hatching with ink. Sudden line wiggles or a portion that got too dark will affect the whole layout of your sketch, and these kinds of inking mistakes are irreversible.

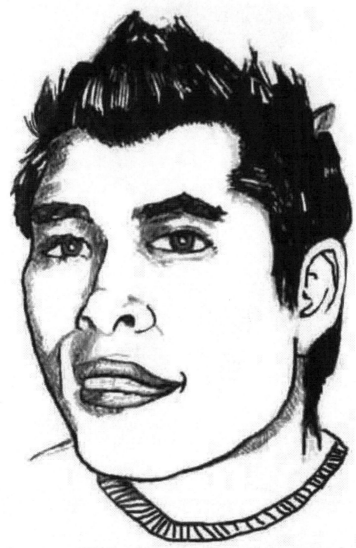

It doesn't have too much detail, only enough to distinguish the person and only contains the elements/features that must be considered. This task is a good way for you to familiarize yourself in sketching a realistic face with ink in a short amount of time, thus, the only facial characteristics observed and then illustrated are only the obvious ones.

Drawing Caricatures with a Pencil

Using a pencil to draw has a lot of advantages. Mistakes can easily be erased and the shade values are much more expressive and adoptive.

Using simple reference lines

Using reference lines make it easier to distinguish the precise angle the head of your model is facing. It will effectively guide you in establishing the change in size and position of any feature which goes with the angle of the head.

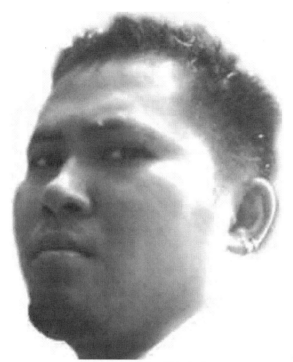

Our model for this task

The head of this model is positioned for a portrait in quarter-turn view, although it's a little tilted which instantly connected the edge lines that should define his chin to the outline of the neck.

The point of light is obviously behind him, which made the unnoticeable jaw line almost unseen. And this kind of lighting means that a couple of shifting gray tones will all be positioned at the front.

In these kinds of portraits with a head in this particular angle, it is easier to start with the part that defines the shape with most shifting lines.

Our model is facing the left so all of the active lines are at the left side. Define the edge lines the outlines his precise frontal head shape, in a counter-clock wise manner.

- Start with defining the length of his forehead and how it breaks for the eyehole.

- Basing on the forehead outline, define the length of the lower outlines, from the edge line of his cheekbone and down to the chin area.

Base on the ridges of the outline that defines the length of his forehead, cheek and down to the edges of his chin to define the angle, mass and height of the whole cheekbone. From there you can easily distinguish where his unnoticeable jaw line ends. Marking the end of his hairline will also help you distinguish how wide his jaw should be.

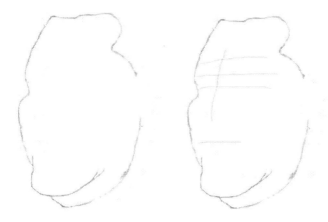

When the edge line of the frontal area is defined, it is much easier to establish the distinct shape of a model's head.

- Now that you have the shape of his head, use reference lines to minimize the chance of placing the features incorrectly.

When using reference lines, you can always base one the realistic shape of your model's head that you already have.

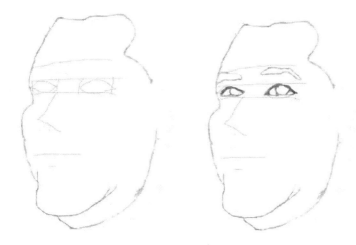

- Mark 3 lines for distinguishing the position of the eyes and eyebrows to serve as a guide for the necessary changes in shape caused by the head's angle.

- Define the outline of the nose to distinguish its length, height and proper angle.

- Use another reference line for the mouth's length to distinguish its actual position.

- Mark another short reference line to distinguish the thickness of his lower lip.

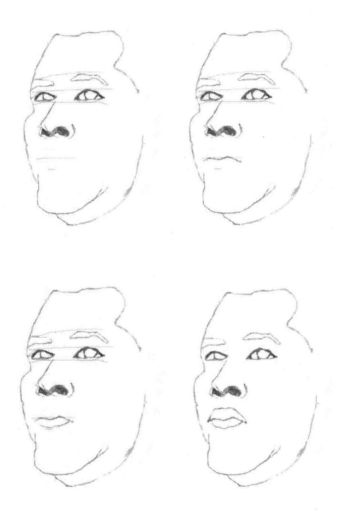

The next step is to establish the exact shape of the facial features with the help of the reference marks you indented. Then thicken what needs to be thick (eyelashes), and darken what needs to be darkened (nostrils).

- Draw a contour line for the shape of the hair. Outline the edge lines to reveal the exact size of the head.

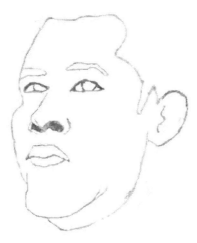

- Darken the facial hairs with thin but dominant lines, mark line strokes in the same direction where the facial hairs are directed.

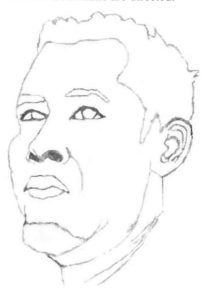

Apply the shades with light hatches (thin close parallel lines) and observe if the tones are properly related to the point of light. Darken the portions that show the folds of his facial ridges by cross-hatching.

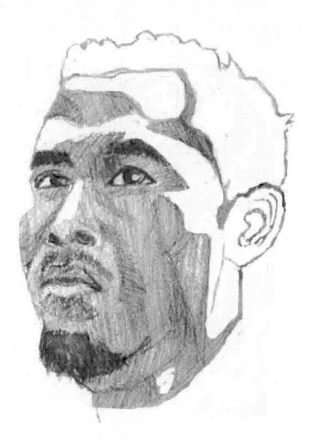

I am aiming for a portrait with blended shades, so I smudged the cross-hatches to lose the visibility of the line marks and create a continuous solid tone in each proportion.

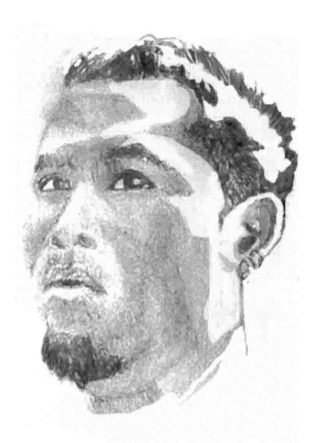

The easiest way to figure out a certain hair texture is to see if the flow of his hair strands are ascending or descending from the hair line.

- Since his hairstyle can be easily distinguished because the hair strands are quite short, establish his hair flow with light and heavy short lines

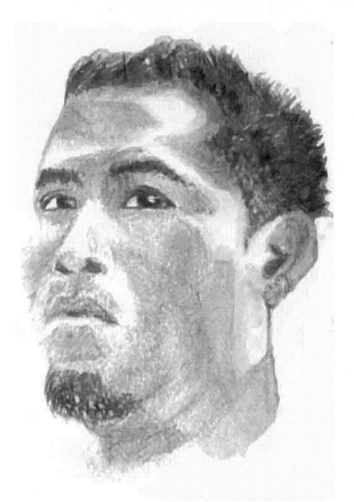

Finalize the drawing by cleaning the excess marks and retouching the details. I slightly decreased the tones to bring out more bright spots on his face. Observe how the eyes gradually got bigger from left to right, this shows that the eyes are quarter-turned to work finely with the dimension of the plane that it should follow, and so does the other features.

By shading with pencil, the portrait becomes more realistic because of the blended tone values. But a drawing with a realistic face alone is not a caricature.

So let's proceed.

Adding Cartoon Bodies to your Realistic Portrait

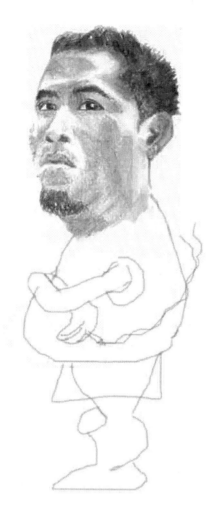

Simply associate the elements of a cartoon into a portrait; a realistic face with a cartoon body is an effective way of creating a caricature.

I use light lines to sketch the basic form of the body to serve as a guide.

In this way, I can easily visualize if the cartoon body I'm going to draw would go with or work with the realistic face.

- Sketch the body first before rendering it with dominant outlines
- Make sure that the shade values of the cartoon body would work well or blend with the tones applied to the face (including the light direction).

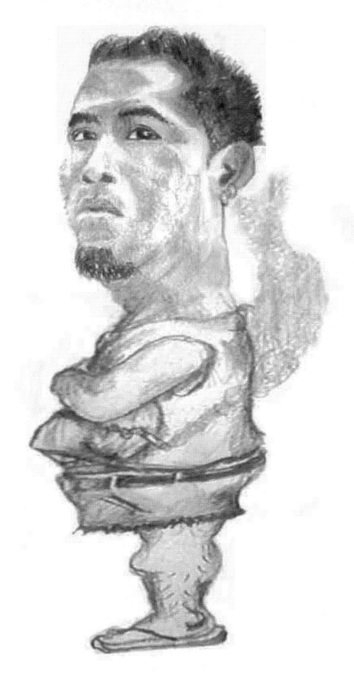

Starting with a Facial Feature

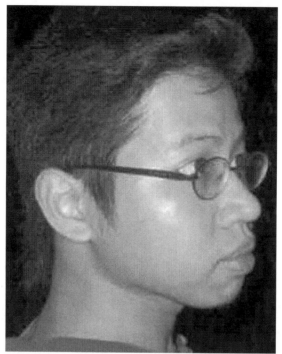

Our model for this task

Let us try to make that kind of caricature once more, and this time let us use a different model.

This person has quite a collection of distinctive features. Observe how the nose and lips are aligned.

- I started with what is at the middle, which is the nose, and I based on it to establish most of the edge lines on the right side.

- Then I defined the length of the lips based on the length of the nose wing.

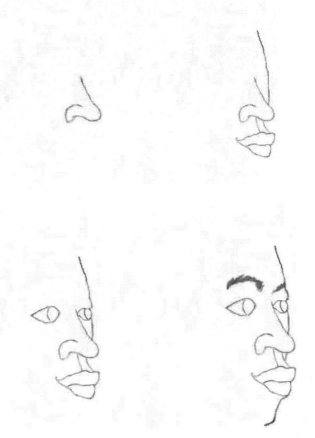

The eyes are also defined by basing on the nose's height and width.

- The gap between the eyes is determined by basing on his nose wing. Observe how the space that the nose wing occupied is closely leveled to the gap between the eyes.

- And to check if the eye is properly laid out, base on the tip of his mouth.

With these established features, all the other outlines that forms the whole appearance becomes easier to convey.

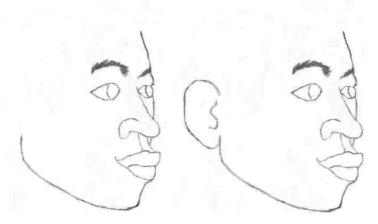

He has a wide jaw and it is very distinctive, along with the big ears that shows its length and whole shape.

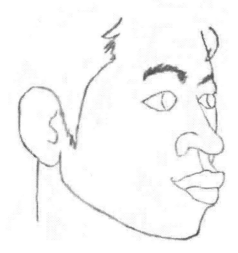

You probably notice how I slightly increased the sizes of his facial features, but even if I did, the lay out of the portrait did not change in proportion, alignment and order.

I do not want to make a certain feature stand out above the rest, Instead, I want to show how his unique features connect and compliment each other.

Amplifying a specific feature will change the face's natural proportion along with its proper shape, and that is how distorting starts.

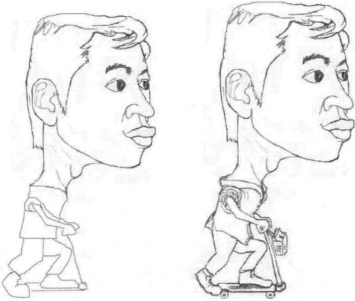

Heads in side view are fitted for body gestures that are active. Bend the arms or legs if necessary to establish the joints and to show proper folds and flexibility.

Instead of making it look like he's just standing there and staring at something, I made it look like he's going somewhere (with his scooter). The pencil grade I used was 4B so I can obtain a darker shade.

Learn how to Draw Caricatures

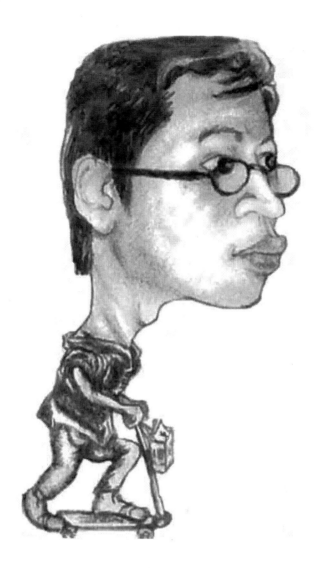

Exaggerating Proportions

 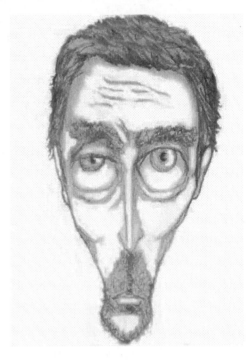

When making a caricature, modifying the general proportion of a person doesn't end in just maximizing the head's size and minimizing the body.

Some caricatures are finished without a body, two of my previous samples (caricature of a child and head in profile) are already considered as caricatures, although it is just a window to introduce semi-realistic cartoons.

When given more effort and observation, head caricatures can even be more expressive and challenging compared to those with realistic faces and cartooned bodies.

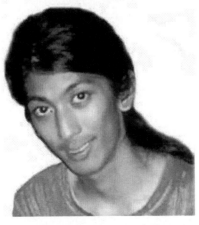

Modifying a person's actual facial proportion is a harder task than it seems. The most challenging part of it is to maintain the resemblance of your drawing to your model.

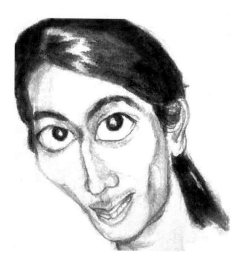

Restructuring the head means adjusting the distances and sizes of each feature, and this is what you must do if you want to get far off from the actual proportion of the head to amplify a particular facial feature.

The key is to reform the shape but maintain the certain angular edges and it's mass.

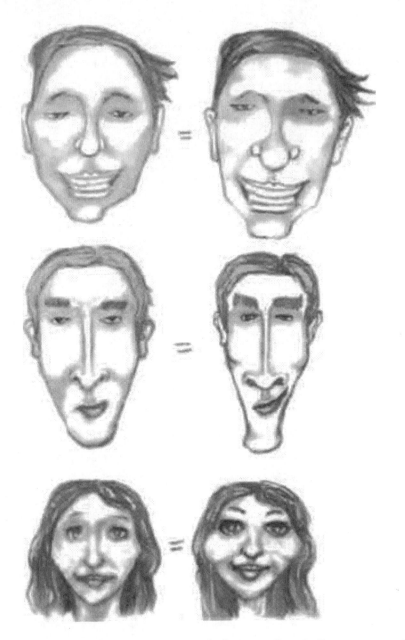

Caricature of a girl – Amplifying facial expression

Some factors must be considered if you are to draw a caricature of a girl. A typical face of a girl has less strong edges. They often have thinner eyebrows and darker eyelashes, the nose usually has slimmer nose bridges and the chin is usually smaller compared to men's.

The facial features of females are basically formed by smooth shape surfaces and so does the shape of the face itself.

When drawing a caricature of a girl, you should try to reduce the usage of thick and strong lines, try to define the details with smooth-flowing curved lines. Although there are cases when some features of your female models are masculine or the shape of her face is angular, this could be fixed by defining their masculine feature with thin outlines or by giving more stress or strength to her feminine features such as her eyes, cheekbones or anything easily distinguishable as a girl's feature.

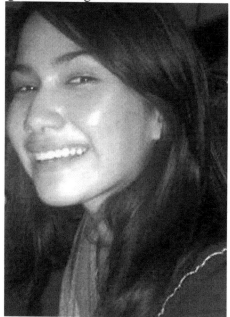

Our model for this task

Aside from amplifying facial features, distorting the proper form or shape is also a way to amplify an expression or a reaction.

As an example, I will make our model above smile wider (way wider).

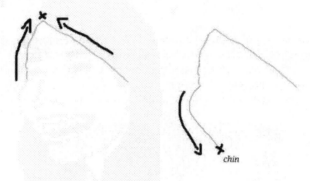

Most of the changes will be done on the lower part of her head, so I started with the upper area, starting with the forehead.

The 'x' mark is where the outlines meet to establish the height of her forehead and its exposure across the whole head.

I find it easier to approximate her hairline and forehead size by making two separate lines meet and form the outline.

- Draw the curve line that would establish her cheekbone, and down to where the outline of her chin would start.

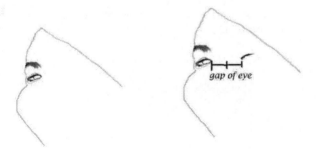

At this point, the space needed to place her eyes in its proper position is ready, so instead of defining the edge lines/outlines of her head completely, I decided to draw her eyes first.

- The size of her eyes is gradually decreased to match the decreased form of her upper head portion.

You may have not notice it earlier, but the slight adjustments in her head's proportion are already initiated from the time I established her forehead.

To make a caricature appear more into the range of realistic than a cartoon (despite the amplification), as long as the distortion doesn't necessarily affect the portion of a feature, then it should be rendered as how it should be in realistic portraits.

- Whether you gradually adjust the distances or change its size, it should still look nearly as realistic as it can.

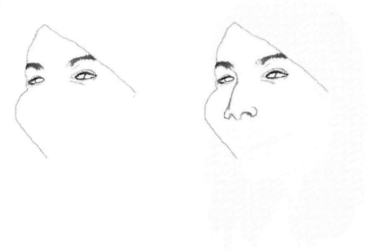

I drew her nose as it is, with its proper distance based on the left (farther) eye and the curve line of the cheekbone.

Learn how to Draw Caricatures

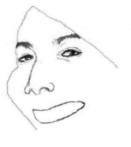 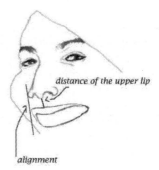

- Even if you are drawing a modified face caricature, some alignments are still considered (unless you purposely twisted the whole face).
- All the facial features, even the modified feature, should still connect or relate to each other, in the same manner as how it relates when in proper proportion.

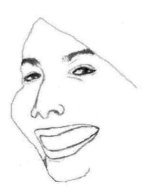

The outline of her mouth that I drew in this step was the mouth that's already exaggerated;

- I made the alignments according to the alignments of features of a head in a quarter turn view aside from basing to the picture given.

Knowing or rather being aware of the appropriate gaps such as the distance of her mouth from the left edge line is something that goes along in any given quarter angled face. This establishes the average proportion of her skull (cheekbones stand out among all the others).

Unlike others' skull frame which has thicker maxilla (upper jaw) or most common is a thicker mandible (lower jaw) that includes how thick or more forward the chin is, females' cheekbones are usually dominant.

- The outline of her jaw should be adjusted, observe the picture and you could see that it aligns to her eyes then ends there.

Because of the wide smile that I drew, the whole face adjusted too. The upper area became smaller to make the lower area look wider.

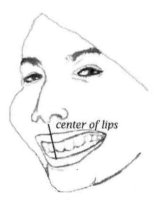

Make sure that the teeth are centered properly. The spikes of the dark tone that shows the inner portion of the mouth will make the order or the look of the teeth more defined.

- The size or length of the other half of the face is defined by the edge line of the inner portion of the hair's contour.

Establish the hair contour that defines the whole size of her head. Draw the contour outline of the portion with most bright highlights to serve as a guide when you start to show the flow of the hairstyle through shading.

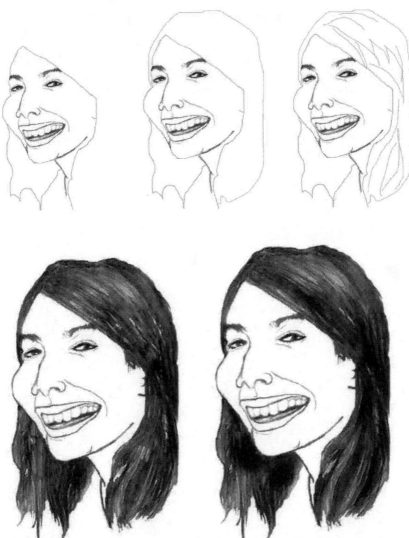

- The line stokes on her hair are blended or smudged, and then layered again with a darker shade.
- The shading values are blended with a piece of cotton.
- Even out the shades on her skin slowly with cotton and re-establish the highlights with the thin edge of an eraser.

- Re-darken the outlines of her eyes to make it stand out amongst all the other tone values.

Even if the caricature is mildly disproportioned by intention, it is still an obvious portrait of the girl since no dominant sharp outlines were used.

Learn how to Draw Caricatures

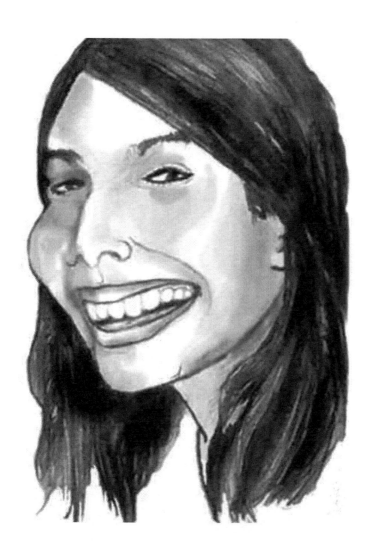

Drawing Detailed Caricatures of Children

In the following example we will take a little longer drawing this young child and adding more details to the face and try to draw a more realistic picture with the detailed features.

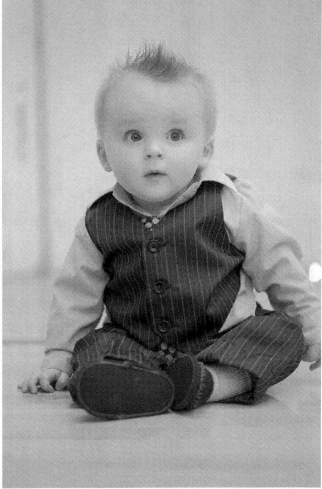

This is our model for this task.

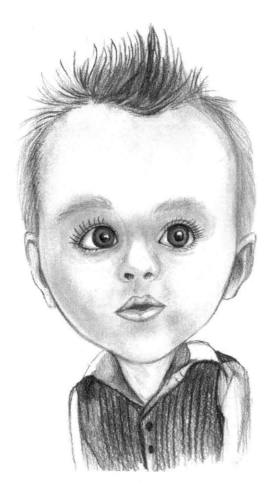

Notice how we exaggerated the eyes and the hair. They are the focus points for the illustration.

Drawing Caricatures of Children and Animals

The next example we will try to add a dog to the picture and combine it with a picture of the little boy.

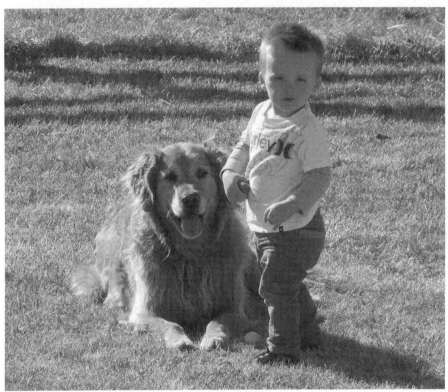

Here are our models for the next caricature.

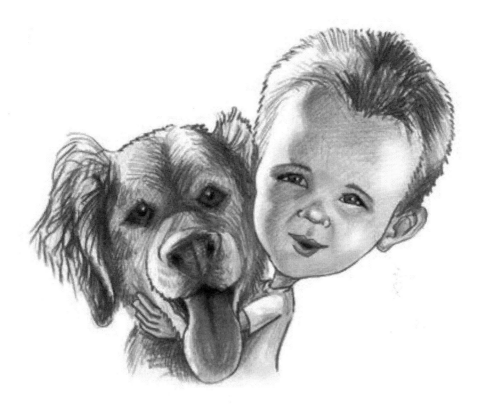

We tried to capture the love between a boy and his dog with this drawing. Adding color helped us to add more realism to the caricature.

Keep practicing and your skills will improve. Keep a sketch book with you all of the time and as you have a minute, try to draw things around you.

Make Money Drawing Caricatures

Once you have practiced and can draw quickly. You can actually earn really good money drawing caricatures. People out for a good time on the weekend love the entertainment of seeing themselves turned into a caricature. Make sure you check into the proper business licenses for your area. All you need is a couple of chairs or benches and an easel and you can be in business. Pick a place that a lot of people go like the park and you can set up shop. Having samples of your work set up helps people see what you can do.

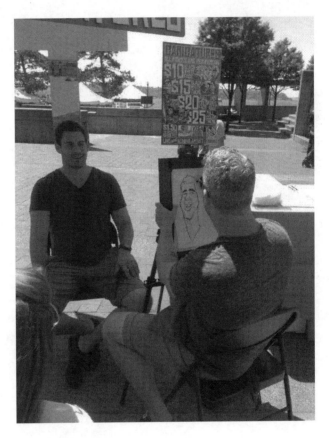

This is a picture of someone doing it in Seattle Washington near the small shops down at the beach.

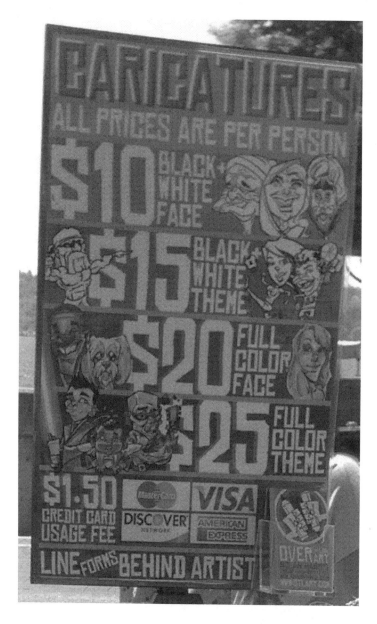

Here is a close up of his pricing.

One other way to make money is to sell your skills on a website like Fiverr.com.

Keep practicing and have fun drawing!!

Caricature Samples

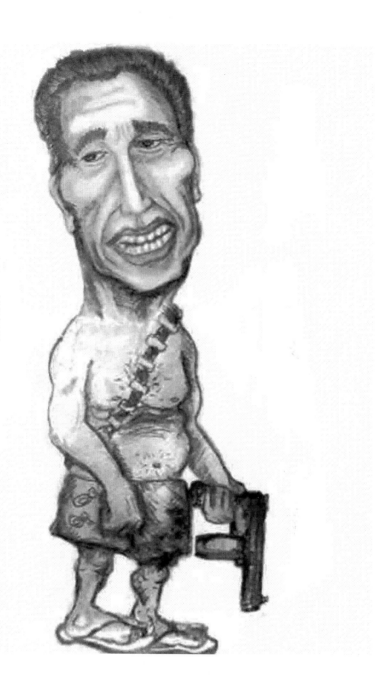

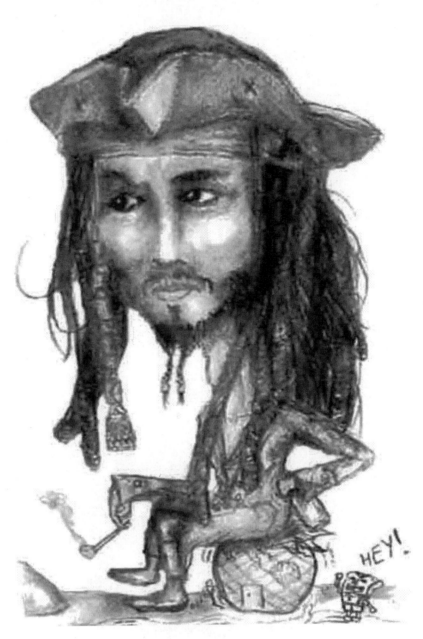

Thank you for reading!

Read our other books

Made in the USA
Middletown, DE
13 December 2024